WISCONSIN POETS
at the
ELVEHJEM MUSEUM OF ART

Elvehjem Museum of Art
University of Wisconsin-Madison
1995

ISBN 0-932900-38-0

Designed by Jim Escalante
Edited by Patricia Powell
Printed by Straus Printing Company

1500 copies of this publication
were printed on Centura Gloss paper,
with Meridian type.

Library of Congress Cataloging-in-Publication Data
Wisconsin Poets at the Elvehjem Museum of Art.
 p. cm.
 ISBN 0-932900-38-0 (softcover)
 1. Art–Poetry. 2. American poetry–Wisconsin–Madison.
 3. American peotry–20th century. I. Elvehjem Museum of Art
PS595.A75W57 1995
811′.54080357–dc20 95-22022
 CIP

On the cover: George William Russell (called Æ) (Irish, 1867–1935),
Children Dancing on the Strand, before 1914, oil on canvas, 17½ x 21½ in.,
Elvehjem Museum of Art, Gift of Patrick Cudahy, 14.1.4

CONTENTS (alphabetical order)

FOREWORD

Aristotle was probably the first to propose a comparison between poetry and painting. He and other ancients considered these two art forms to be the most important and the most worthy of practice and discussion because more than other art forms they were capable of imitating human action. Poetry and painting were perceived as almost identical in nature, in content, and in purpose, differing only in their means and manner of expression.

Ever since, *ut pictura poesis* (as is painting so is poetry), as this concept was later called in Latin, has played a vital role in the development of artistic and literary theory throughout western history.

On various occasions, the theoretical relation between the written word and visual imagery has even moved beyond discussion into actual practice. Numerous authors over the centuries have derived inspiration from paintings. *Ekphrasis*, or description, in the second century A.D. was the rhetorical exercise of creating mental images through words and frequently began with a description of existing works of art. Since the seventeenth century, poets have written "concrete poems," in which the words were arranged on the page to form an image or visual pattern. On the other hand, it is well documented that painters have on many occasions attempted to translate literary images onto canvas. The present volume draws its inspiration from this long and venerable tradition.

Appropriately, the publication of *Wisconsin Poets at the Elvehjem Museum of Art* coincides with the celebration of the Elvehjem's twenty-fifth anniversary. The combination of elements and the way they came together to produce this publication effectively symbolize the museum's continuing role within our community: the art collection, dedicated museum volunteers, the intellectual and technical resources of the university, all stimulating and encouraging the creative impulses of yet another generation of artists.

The origins of *Wisconsin Poets at the Elvehjem Museum of Art* go back to February, 1992. Two of our most dedicated volunteers, Beatrice Lindberg and Sybil Robinson, searching for new ways to teach art appreciation to museum visitors, organized a gallery tour and poetry reading called "Poetry about Art." Focusing on popular works in the permanent collection, Ms. Lindberg gave an art historical introduction to each piece which was followed by a relevant poem read by Professor Robinson.

Public response to the initial program was very enthusiastic, and more such programs were demanded. The one hurdle to be overcome, however, was that not enough existing poems related to the works on display in the museum's galleries. This made the educational goals of the program difficult to achieve. The two unusually enterprising docents responded by inviting individual poets as well as members of poetry societies such as the Wisconsin Fellowship of Poets, Cheap at Any Price Poets, and Root River Poets to compose new work on objects in the museum's collection.

Over the course of the next three years, poets from around the state visited the museum and selected an object on view which they personally found inspirational. Over one hundred and fifty new poems were produced in this manner and submitted to the museum for use in the poetry and art program. The overall quality of the writing was exceptionally high, and public response to the readings was so overwhelming that eight additional public poetry and art programs were held. Many of the poets had traveled long distances before writing their poems and then returned to hear their poems read. Subsequently, additional readings were broadcast throughout the state on Wisconsin Public Radio.

"Poetry about Art" attracted poems of such high quality that the decision to publish was inevitable. Unfortunately, the financial implications of such a publication precluded including all of them. A selection committee was formed and put under the able guidance of Ronald W. Wallace, director of the program in creative writing at the University of Wisconsin-Madison. The group consisted of Anne Lambert, curator of education, and Pat Powell, editor, Elvehjem Museum of Art; Bea Lindberg and Sybil Robinson, initiators and presenters of "Poetry about Art." Although literary merit was an important criterion in the selection process, it was not the only one. The committee also gave much consideration to those works which, in their view, best exemplified the purpose of the program, that is, poetry inspired by an encounter with a work of art in the Elvehjem's permanent collection. The final selection only includes one work by any given poet although several individuals submitted more than one. Also, only one poem about any single work of art was selected although in several instances more than one poet focused on the same painting. Thus not all the poems considered of significant literary merit have been published. The present publication only includes thirty-two poems by thirty-two poets about thirty-two different artworks in the museum. It is also interesting to note that the poets selected represent ten Wisconsin cities, including Appleton, LaCrosse, Madison, Milwaukee, and Racine.

Because poetry is an aural as well as a visual art, an audiotape with readings of the published poems by Sybil Robinson, emerita professor, and John Staniunas, assistant professor, both of theater and drama at UW-Madison, was produced and is available. Thus the book can stand alone or can be used with the tape as an audio poetry and art guide to the museum collection.

In addition to those contributions to this project mentioned above, I would like to acknowledge the valuable work of Jim A. Escalante, associate professor of art at UW-Madison, who designed this elegant volume; of Anne Lambert, our curator of education, whose on-going task it is to nurture such an outstanding group of docents; of Greg Anderson, UW-Madison Photographic Media Center, who produced these excellent photographs; and of Pat Powell, our editor, without whose efforts this publication could not have been realized.

Thanks are also offered to all of the poets who submitted work to the poetry and art program. These talented writers have brought the pen and the brush together at the Elvehjem Museum of Art and once again delved into an exploration of the age-old link between painting and poetry. We regret very much not being able to publish all of your wonderful creative efforts.

Funding was generously provided by the Evjue Foundation/The Capital Times and by the Dane County Cultural Affairs Commission.

Russell Panzcenko
Director

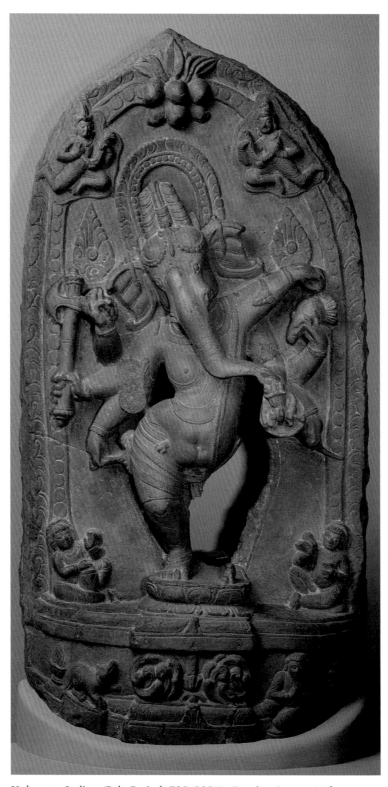

Unknown Indian (Pala Period, 730–1086), *Dancing Ganesa*, 11th century, carved black stone, 24¼ in. H. Gift of Mr. and Mrs. Earl Morse, 1972.27

Exercise

Whoever said an elephant can't dance
 has never seen good old Ganesa prance.

With a long trunk and all those arms to boot,
 Ganesa doesn't even miss his foot.

Amazing what this elephant can do—
 and with imagination, so can you.

Try. Go ahead. Pretend you're standing flat
 on one dime.

Now scratch yourself in seven places at
 the same time.

Mel Koronelos

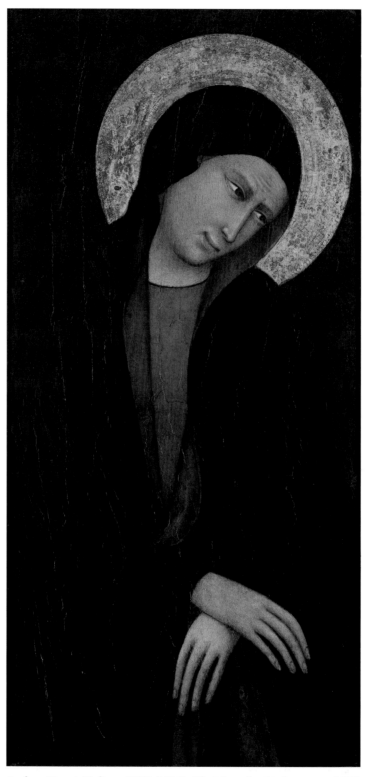

Andrea Vanni (Italian, 1332–1414), *The Mourning Madonna*, ca. 1375,
tempera and gilt on panel, 21⅞ x 10¾ in. Gift of the Samuel H. Kress
Foundation, 61.4.10

The Mourning Madonna

The hands are
self bound.

She unconsciously remembers
her son's.

What is there to do
with brute demolition

but submit

and become
the ellipsis of grief?

We tiptoe around
this pure example,

set off by the embossed halo,

with the mourning colors of moss-green
and marble-pink in her face,

her dress lined with
the violet opening
of one's veins,

its coral mantling
the intense
and private interiors
of the body's flesh—

He has done well
to portray the chastity of
her sorrow

with the eloquent poverty
of tempera upon wood.

Mary Gallagher Price

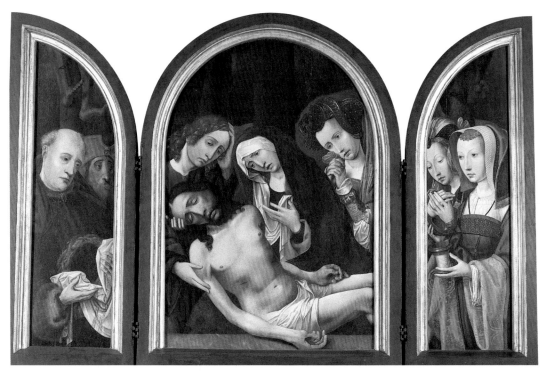

Colijn de Coter (Flemish, ca. 1455–ca. 1540), *Bernatsky Triptych: The Lamentation*, ca. 1500-1510, oil on panel, 41½ x 29⅛ in. (center panel). Gift of Charles R. Crane, 13.1.1

Pietà

His flesh transforms to ash—
His mother's, just the same.

His father's knobby hands curve up
At the end of *His* long arms, like hand-carved

Wooden spades. A young man cries, "Oh no,
Oh no!," but the elders have resigned themselves

To this. The women gather, pious as nuns,
Yet curious, beside the young mother

Who still does not believe
Her son can feel this cold:

She cradles His neck in the palm of her hand
So His head won't fall back—so He might stand again

On less treacherous ground.

While the thieves still hover
On their crosses, black clouds gather:

The women stand ready
To perfume and wash the body,

But the mother leans, frozen in a pose,
Unable to give this precious gift again—

Unable to believe
She must.

Elaine Cavanaugh

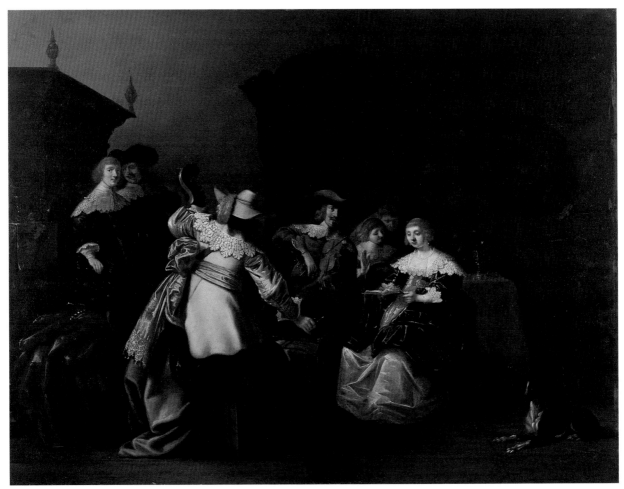

Anthonie Palamedesz (Dutch, 1600–1673), *The Musical Company*, ca. 1635, oil on panel, 17¾ x 24 in. Gift of Mr. and Mrs. Marc B. Rojtman, 62.1.2

A Musical Company

Flinging off a red wrap and
not bothering to remove their hats,
the musicians tune up promptly.
Music thrown down on a bench,
books passed to the ladies of the house.
Resplendent in voluminous dresses
fancy lace collars, they trill
a lively tune, as a small hand beats time.
Their efforts, not too offensive,
the dog refrains from howling.

A strange group
a bass viol, violin, voices.
Rock and roll bands centuries away.
The company—long silenced.
Perhaps the gold of their clothes
gives off glissandos, the orange sash
and plume perform pizzicatos, the
vermilion vibrates voice tremolos,
the pink shoe bow beeps a grace note
in the song of color.

Phyllis Reisdorf

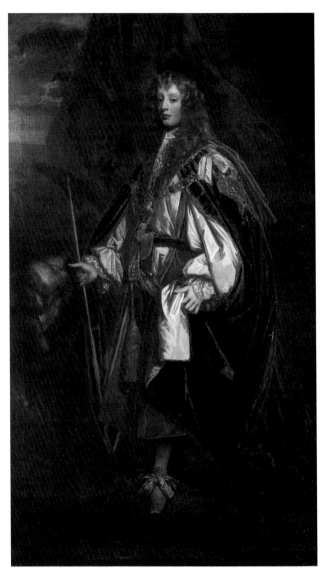

Peter Lely (English, b. Germany, 1618–1680), *Thomas Butler, Earl of Ossory, First Duke of Ormonde,* ca. 1675, oil on canvas, 90 x 52½ in. Gift of Charlotte C. Gregory, 64.15.15

Introductory Comments by Sir Thomas Butler of Offrey

I,
Thomas Butler—
Earl of Offrey,
First Duke of Ormonde—
I,
Gift of Miss Gregory
and Model for Peter of the Flowered Name,
bid you
"Well come to the Elvehjem Museum of Art."

Looking down upon you, indeed,
I prove
a Sensuous Sentry of Note,
a Master of Wit
as I
"draw" your attention to
 this wonderful wig so delicately framing my magnificence
 (and matching my eyebrows)
 these piercing eyes that capture your gaze (wherever
 in my presence you may be)
 that proboscis of noble length (satisfying rumors of another
 large appendage) and
 the hairy accents of masculinity (which separate these fabled
 "luscious lips of experience").
Envious sir or stirred madam,
you may worship at the Altar of Perfection . . .
marvel at the Displayed Magnificence . . .
swoon over "That Which You May Not Touch" . . .
but you may not take this garb for granted!
You may not dismiss
each piece
(so carefully selected)
each piece that dresses and drapes
the priest
for his sacrificial lambs—
 the dangling tassels of braided gold,
 the lace, ribbons, satin, velvet, pearls, and jewels,
 the shoes with silvered buckles and well-stacked heels,
 the undergarments of raw silk and imported linen . . .
each piece
(so carefully selected)
each piece
 so prized as it augments man to Divine.
I, Thomas Butler,
rightfully bathed in a halo of light
I, Thomas Butler,
with plumed hat
resting within reach (ready
to cap this Man Among Men)
I, Thomas Butler,
bid you
"Fare well."

(You have seen the peacock, now you may visit the hens.)

Mary Louise Frary

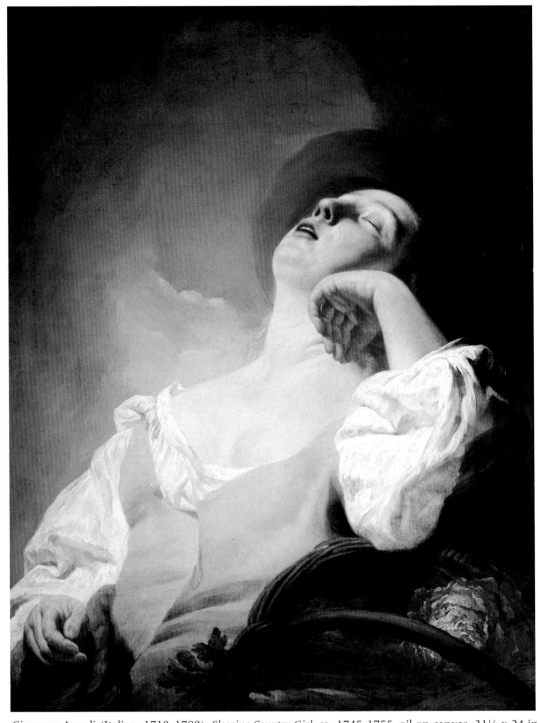

Giuseppe Angeli (Italian, 1710–1798), *Sleeping Country Girl,* ca. 1745-1755, oil on canvas, 31¼ x 24 in. Gift of the Samuel H. Kress Foundation, 61.4.2

Sleeping Country Girl

Let's recall what
It is like to be
Completely at ease.
I forget myself,
But she knows.

You see she closes
Her eyes to
The circle of
Threatening clouds.

Perhaps she even
Keeps them at bay,
Pulling the sun through
By the strength
Of her trust.

Having basketed
Celery and cabbage,
She contents herself.
Who needs anything more?

Vulnerable and unafraid
Her fingers curl inward
Like a baby's. She draws
Her breath unimpeded.
Who would dare touch her?

Let's hush. Unless
We would wake her
And send her out
To make a name
For herself.

Margaret Rozga

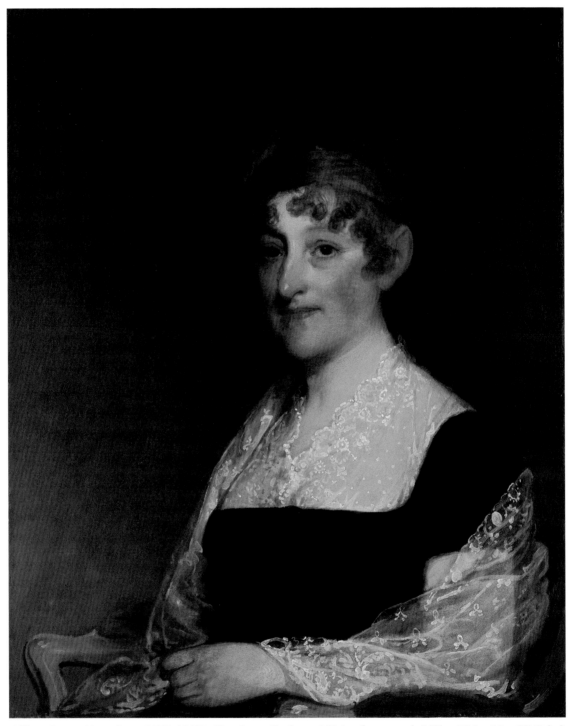

Gilbert Stuart (American, 1755–1828), *Mrs. Aaron Davis,* ca. 1816, oil on panel, 28⅝ x 23 in. Max W. Zabel Fund purchase, 68.5.2

To Gilbert Stuart from His Subject

You amuse me as you struggle
to ensnare my eyebrow's arch
or trace precisely what space lies
between my nose and lip.
Concentrating so on parts, you never see the whole
or grasp the meaning of the tiny smile
I wear for you.

You do not know—or care—if my name be
Elizabeth or Patience, Prudence, Martha, Mary, Jane . . .
Aaron Davis paid for this commission,
so I will be recorded for eternity
as merely your old client's dark-eyed wife.

My revenge for anonymity
will be that I remain in it—
nameless, void of both a dream
or an accomplishment the world can learn.
Did I love someone else before I wed—
have I loved someone since? I will not say.
Have I been wicked or angelic, cold,
devoted, spiteful, rigid, wild?
No one will know.

I seal my lips together firmly,
look at you with wise eyes saying, "Guess,"
assume a mystery for posterity.

Jo Bartels Alderson

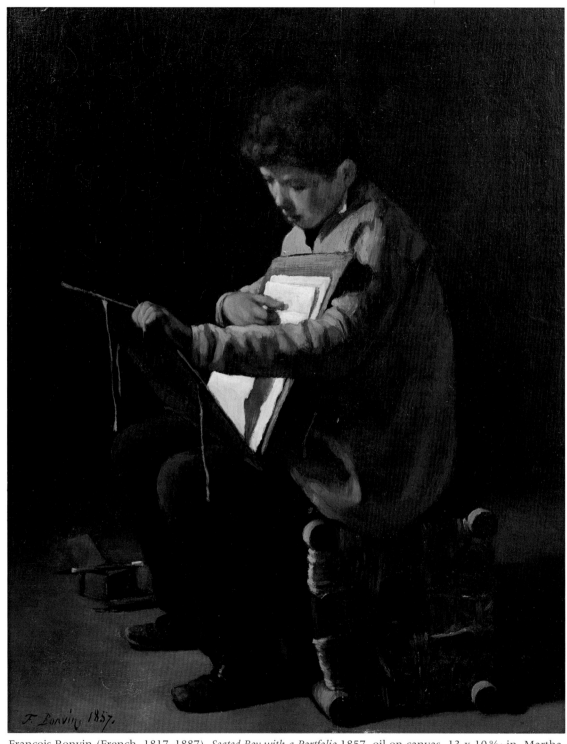

François Bonvin (French, 1817–1887), *Seated Boy with a Portfolio,*1857, oil on canvas, 13 x 10 %16 in. Martha Renk Fund purchase, 1982.57

Seated Boy with a Portfolio

That fifteen-year-old look
so like your own:
bent shoulders, loose shirt
draped around slender body.
His tired, black shoes
meet proper black pants.
Your brand-new white Nikes
brush faded jeans.

But it's his face, framed by swirls of black hair,
that captures me,
reminds me of you.

You almost finished a self-portrait,
coaxed pansy faces alive,
settled songbirds on delicate twigs.

His brush lies silent
as he studies the portfolio.
Do his pastels let daffodils dance,
allow maples to scan the sky?

It's his face that captures me,
so like your own,
the face some girl will love,
the face I'll cherish
without Bonvin's painting.

Kay Saunders

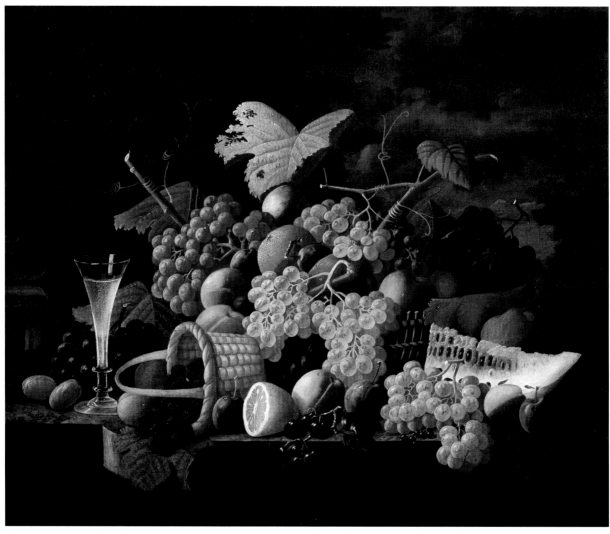

Severin Roesen (American, ca. 1815–1872), *Still Life with Watermelon*, ca. 1858–1871, oil on canvas, 29 x 36⅛ in. Max W. Zabel Fund purchase, 68.22.1

Still Life with Watermelon

Even before Roesen painted his masterpiece
it was a work of art, strawberries tumbling
from artfully tipped wicker, that wine glass,
how well placed, those grapes someone snipped
slantingly from the vine,
how cleverly they are clustered with cherries
among the larger fruited globes.

But it was his brush made the velvet-skinned
peaches glow like setting suns,
the leathery rinded orange
gleam like fish scales;
his brush that dusted the cool purple plums
and smoothed the nectarines,
glistened the sliced lemon
and dotted the watermelon's black seeds
into their crevices as randomly as nature.
It was his brush, you must believe me,
wound that escaping tendril into his signature,
and munched those holes in that otherwise
perfect leaf.

Karen Updike

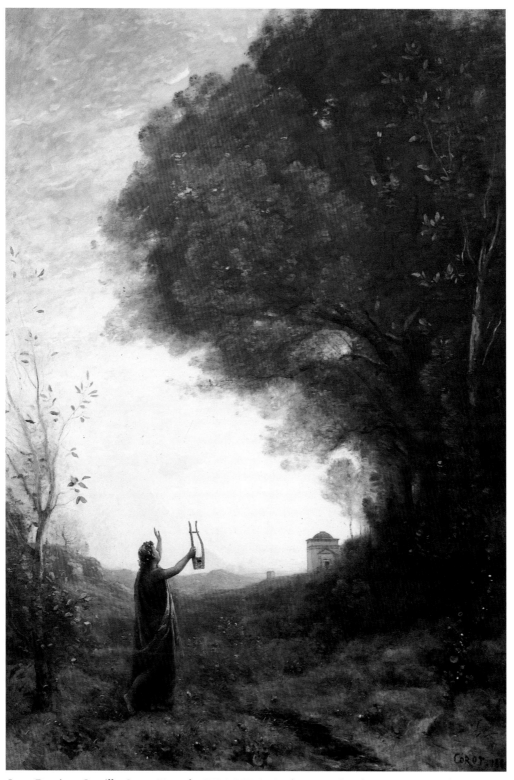

Jean-Baptiste-Camille Corot (French, 1796–1875), *Orpheus Greeting the Dawn*,1865, oil on canvas, 78¾ x 54 in. Gift in memory of Earl William and Eugenia Brandt Quirk, Class of 1910, by their children, 1981.136

Orpheus Greeting the Dawn

To get into my landscapes you need to have
the patience to wait for the haze to lift; you can
enter them only by slow degrees.

Corot

This colossal tree
Oppresses. The sky runs from the wind.
A gray and silver opalescent light
Is spreading from behind a distant temple
To summon Orpheus to this woodland rite.

Leaving the dim path, turning to Aurora,
He greets her early: Dawn is yet half-dressed.
Poised at his full height he lifts the lyre,
And lifts the hand that is to make its music,
Serene, attending Apollo's benediction
In absolute expectancy. This is
The offered moment, confluence of power.

And now a sapling, close to Orpheus,
Curving toward the Dawn, receives its leaves
Bold as birds alighting, green and gold
Like little lyres themselves. Now at his side
Pinpoints of rose appear on a wild bush.

Orpheus the singer—we knew he brought the trees
And flowers to life: we heard it all in childhood.
What we now know, the haze having risen, is how.

Josephine M. Zell

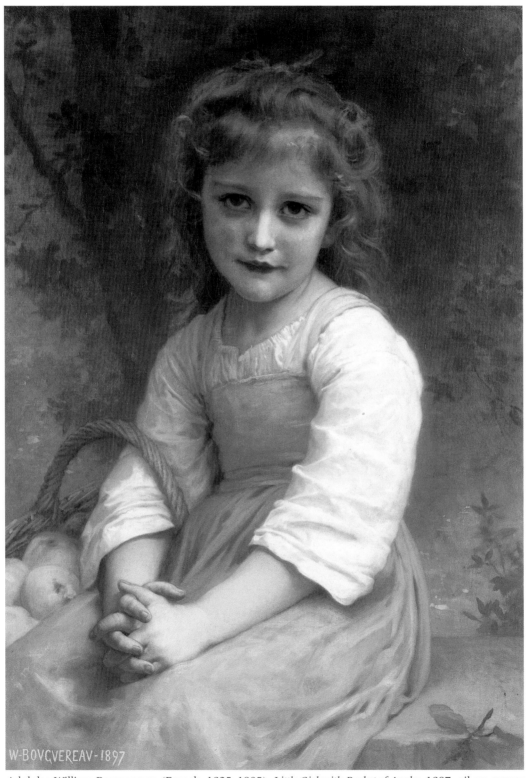

Adolphe-William Bouguereau (French, 1825–1905), *Little Girl with Basket of Apples,* 1897, oil on canvas, 25⅝ x 20⅛ in. Bequest of Harry Steenbock, 69.5.2

Little Girl with Basket of Apples

across the room
you seem to glow
calling to me silently
those pale brown eyes
cast shyly upward
softly beguiling
on this summer day
small green apples
by your side

vision of the past
recalling innocence
a season without edges
bringing forward
one sweet moment
to rebuke these
coarser times

silken ribbon
in your hair
sets off its soft
brown color
subtly points out
reddened cheeks
faintest track of tears
the mouth
a little wary

behind that smile
do I see sorrow
more profound
than apple's ache?
do little girls
whatever era
cry more often
than we know?

Pat Kardas

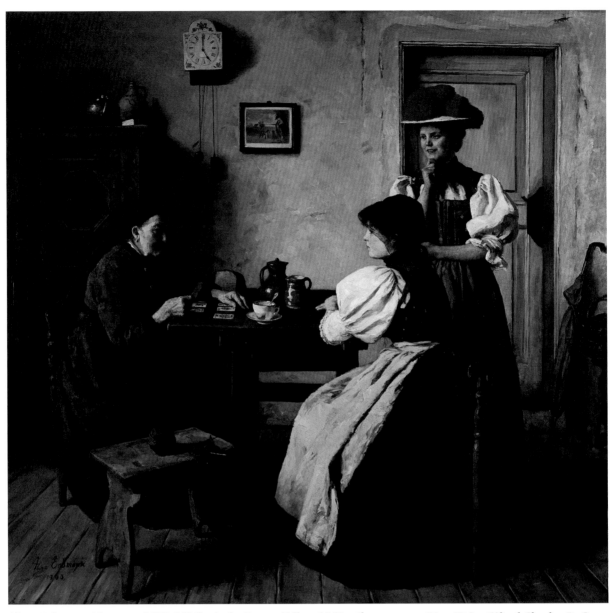

Alma Erdmann (German, 1872–1930), *At the Fortune Tellers*, 1900, oil on canvas, 50 x 52 in. Gift of Charles R. Crane, 19.1.2

The Moment before Speaking

While one century
gives way to the next,
three women await change.
The seer and the maiden exchange gazes.
One looks at yesterday,
one at tomorrow.
The Fortune Teller
reads the girl's lot
from living her own.
Studies the maid's face
as much as the cards.
Though the young be deaf to guidance,
she will counsel the child
with all that she knows.
The scent of their peppermint tea
permeates the plain wood of the room.
The companion of the girl
stands awhirl with impatience.
The tick of the clock
is all
that breaks their silence.
But this moment holds still,
the one before speaking.
What will be told,
what held back?

Sue Silvermarie

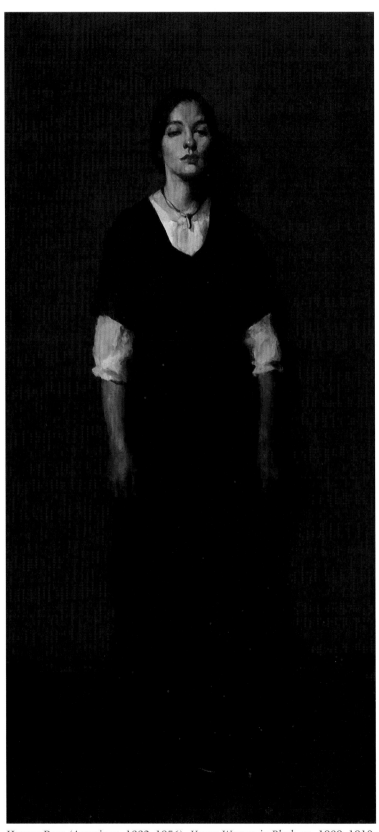

Homer Boss (American, 1882–1956), *Young Woman in Black*, ca. 1909–1910, oil on canvas, 74 x 35¾ in. Gift of Mr. and Mrs. Jon G. Udell in memory of Suzanne and Homer Boss, 1978.18

Young Woman in Black

What do you expect of me?
I have come thousands of miles,
worked this land alongside you,
borne four children to carry
your name down eternity's
pathways while my name is lost
in the winds of time, yet still
 you want more!

Your look severs each tie
that bound us, your voice
wrings me dry. Each morning
I rise and listen for the meadowlark—
you kill its song in my ears.
I stand on your land; my
sweat has watered its harvest
but I do not profit—you
 carry away the fruits.

Now it is time for me
to walk away;
you can work the fields alone,
sit at your table alone.
I'll sing with the meadowlark,
plant a garden,
 make dandelion wine.

Charlotte A. Cote

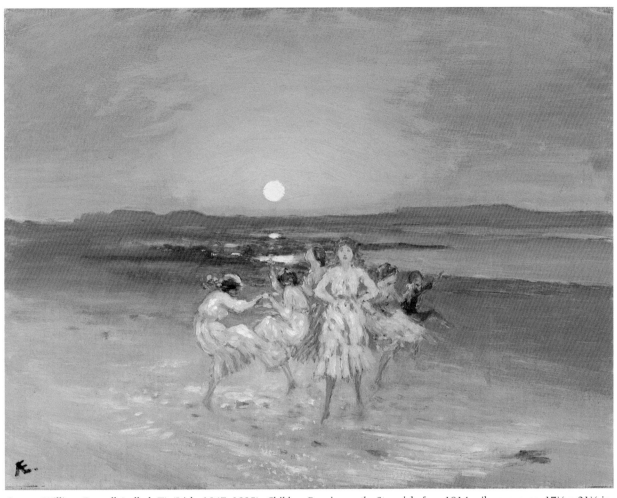

George William Russell (called Æ) (Irish, 1867–1935), *Children Dancing on the Strand*, before 1914, oil on canvas, 17½ x 21½ in. Gift of Patrick Cudahy, 14.1.4

To the Children Dancing on the Strand

Not everyone walking that stretch
of beach would succumb to the moon
with such abandon,
slender legs kicking the air,
arms flung wide.

White dresses capture light,
one pale pink sash tells
a tender waist, blue on blue
is sky and lake. Everyone's hair
floats on the wind.

Who could name the steps?
The girl in the foreground seems
to point a ballet toe. Those partners,
holding hands, might be dancing a fandango
on the golden sand.

Caught forever in the early dusk,
the artist paints, the children dance.

Helen Fahrbach

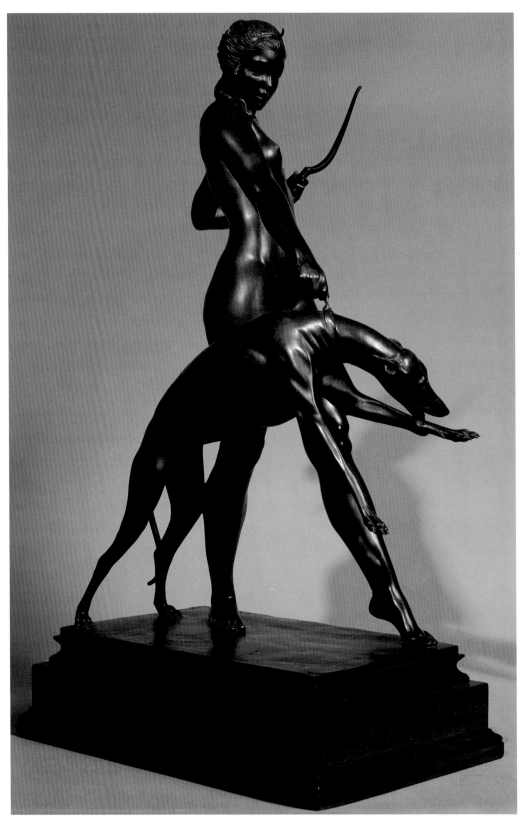

Edward McCartan (American, 1878–1947), *Diana*, 1923, cast bronze, 23 in. H. Gift of Mrs. Robert E. Friend, 64.6.1

I Am Artemis/ I Am Actaeon

I am Artemis, Goddess of the Hunt and of the Moon.
I turned Actaeon into a stag,
Slain by his own hounds, when he came upon me
Bathing in my favorite mountain stream.
Let this be a warning to all men whose eyes
Violate the sanctity of a goddess.

I am Actaeon, hunter and hunted,
Who learned before he died as a beast,
What a goddess looked like bare.
She looked like a statue ten feet tall,
Made of marble and beautiful beyond speaking,
But terrifying in her frozen virginity.
She held me in her gaze; I could not avert my eyes
From her massive nudity.
Then the stag-form began to reweave
My nerves and muscles;

I screamed in pain
Until a heavy unawareness,
Broken only by the cry of distant dogs,
Crept over me,
And I was no longer myself.

L. S. Dembo

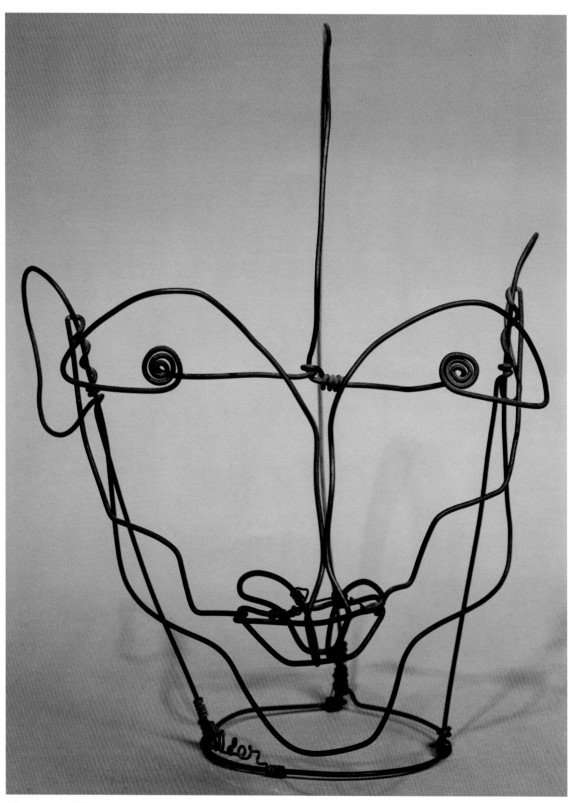

Alexander Calder (American, 1898–1976), *Head of Michel Tapie,* ca. 1930, wire, 12⅝ H. Bequest of Alexander and Henrietta W. Hollaender, 1992.310

Rebuilding the Head of Michel Tapie

Your head is old a hard vine
twisting from the center
of the earth It speaks
the language of scaffolding
Tonight I watch your mother
walk across the bridge

of your forehead a frozen
arc a dolphin rising from water
She carries pliers in her pocket
as though she might change
the shape of your life as if
the half circle of your eye

is really a door she can open
can lean against to study
double-looped rooms where you
no longer live She wanted
you to be a doctor like your

father not this bundle of wire
not this metal armature
much too fragile to hold
the weight of bone and flesh
She bends slightly into

the apparatus of your ear
turns carefully to avoid thorn-
sharp edges She does not
understand how this intricate
cage of your head can
be filled with sky
can hold the thankfulness of moon

 Ellen Kort

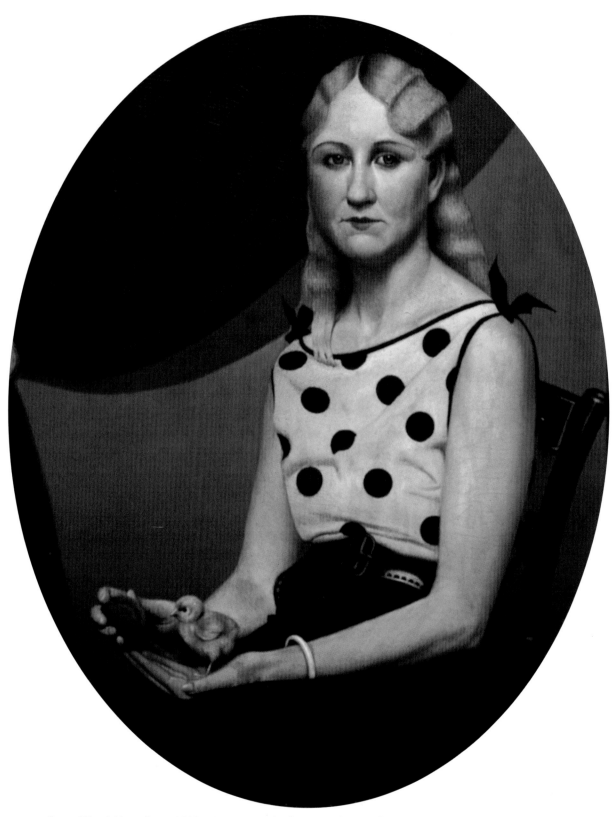

Grant Wood (American, 1892–1942), *Portrait of Nan*, ca. 1933, oil on masonite, 34½ x 28½ in.
Courtesy of the Collection of William Benton

Talking Back to a Portrait Hanging on the Wall

Nan, you are sunday morning in the french quarter
your eyes tell me
you spent the night at Napoleons
sitting next to a window with no glass
drinking some kind of whiskey
while that guy with the dark skin
played a saxophone in the corner.
This painter sat across from you
bought you drinks
asked about Natchez
and why did you drop out of Tulane?

Summer is slow
iced coffee goes down like an elixir
ceiling fans hypnotize
and that man on the corner
who calls himself a chessmaster
talks of going up north to the resorts in the Catskills
where you should be.
Instead, you let yourself become beguiled
by this funny, little man
calling himself an artist,
trying to get you into bed
begging to paint you.

Now, on sunday morning in the french quarter
you sit in his studio
listening to his whiskey filled sighs
and the swirling fan above
you're just about to smile
when he says, "hold it."

You're no Mona Lisa, Nan
crimped blond hair is sassy
and polka dots too bold to seduce
but he painted you anyway,
even gave you a baby chick to hold in your palm
while you held in laughter
on sunday morning in the french quarter.

Cate Riedl

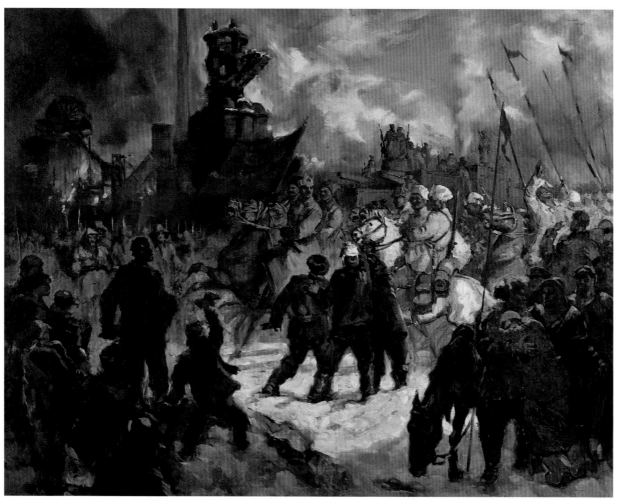

Pavel Sokolov-Skalya (Russian, 1899–1961), *Red Army in the Don Basin*, before 1937, oil on canvas, 46 x 59 in. Gift of Joseph E. Davies, 37.2.47

Red Army in the Don Basin

These four figures, here in the corner:
is it the passage of time that has caused them to turn
their backs on the scene? The red flag flares
over the general, proud in his greatcoat, reining
his rearing steed. Cossacks in fur hats and homespun
follow in ranks, victory theirs, the sky clearing,
storm clouds retreating, lances unfurling red pennants
into the blue forever—

 In the distance, olive drab
soldiers stand guard on tanks boxy as pedestals.
Industrial fires burn: a steel mill throbs,
its workers mass to welcome the horseback general
into the modern age. Then why is this *babushka*
kneeling, or near collapse? Is her husband dead?
Is she ill? She falls into someone's arms,
her daughter's perhaps; the fierce-eyed young woman
consoles her and two peasant friends who look on.
Behind them, a horse noses for grass
in the snow-covered, boot-trodden ground.

Judith Strasser

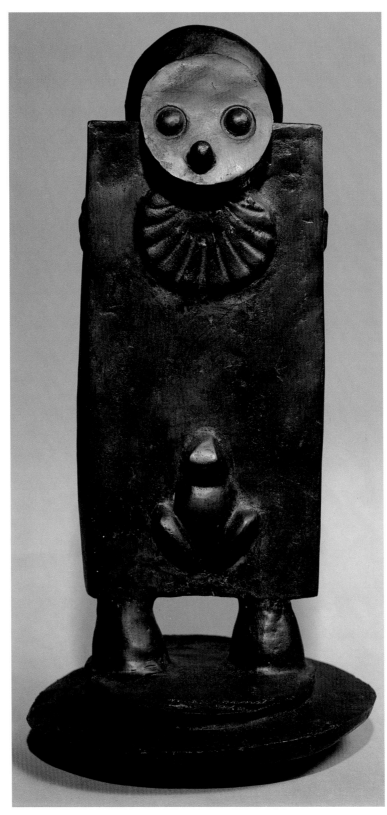

Max Ernst (French, b. Germany, 1891–1976), *Janus*, bronze, 17½ in. H.
Bequest of Alexander and Henrietta W. Hollaender, 1992.215

Janus

I.

Doublefaced sentry,
burdened
into door itself,
budgeless,
mute archway
of indecision.

II.

She sits on edge
in a room
grown strange
in her absence.

Plaid flannel
inches near,
the old embrace,
their two faces
once more
opposite.

III.

Wide eyed duck,
islanded between
river and land,
face frozen
in an incessant "Oh!"
the comic shape
of another beginning.

Cristine Berg Prucha

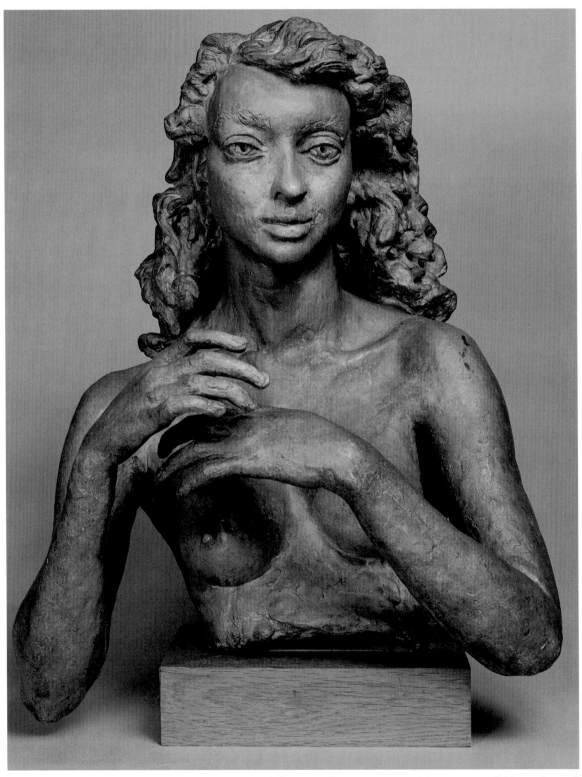

Jacob Epstein (British, b. America, 1880–1959), *Deirdre*, 1941, bronze, 25 x 23⅛ in. Bequest of Alexander and Henrietta W. Hollaender, 1992.218

Deirdre

What did that sculptor see in you,
Deirdre,
and has he truly captured you
waiting for Noisiu, warding off that king
whose evil heart you stirred to your undoing?
Or is this really Eve just at the moment
she sees that she is naked by the new
gleam in Adam's eye?
 No, forget that.
She is after all the forest, not the garden.
Those deep-set eyes want to keep their secret.
She does not want us to look at her.
Alas, I see those hands outstretched
toward the last butterfly
at Terezin.

Bea Cameron

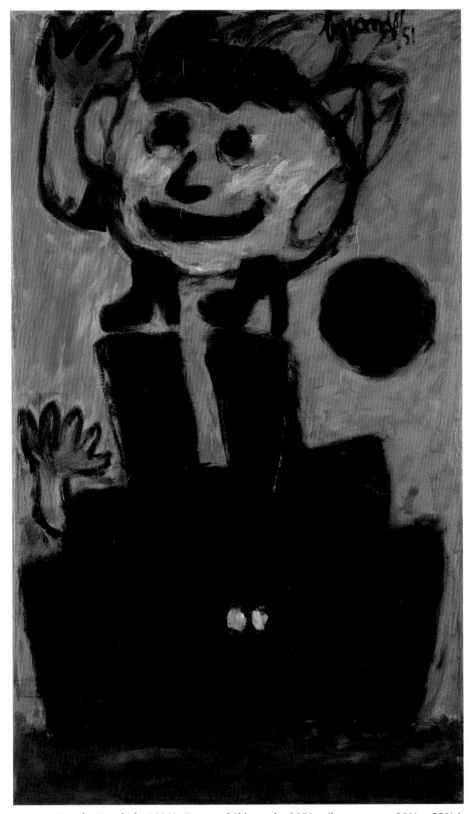

Eugene Brands (Dutch, b. 1913), *Demon of Shipwrecks,* 1951, oil on canvas, 39⅜ x 23⅜ in.
Gift of Alexander and Henrietta W. Hollaender, 1981.254

Demon of Shipwrecks

He stands, a high-heeled warrior's boot
on each black chimney of the doomed ship,
his right hand raised, alert,
ready to give the go-ahead,
his mouth agrin with foreplay satisfaction;
the greenblue waves still peaceful
beneath a darkening full moon.
As he starts moving the silent vessel,
his weight swinging from side to side,
a hand appears out of a cabin.
Saluting? Begging? Waving in great alarm?
It is his own left arm,
cut off his rotund body,
signaling all is well down there, prepared
for surprise sinking: the crew asleep,
the captain's foggy head bent deep
over a book and drinks.
Only two lit-up portholes signs of life:
an owl's nightpiercing eyes
without his warning hoots.

And now the Shipwreck Demon
begins that treacherous plunge as fast,
as nearly perfect as he knows how:
the unexpected squall, the gale strength
winds, the ship capsizing . . .

All of a sudden I see my great-grandfather's face,
who on a stormy night so many years ago
went to the bottom of the Chinese Sea
with his Dutch wife, his ship, all hands aboard,
leaving four children orphaned.

Iefke Goldberger

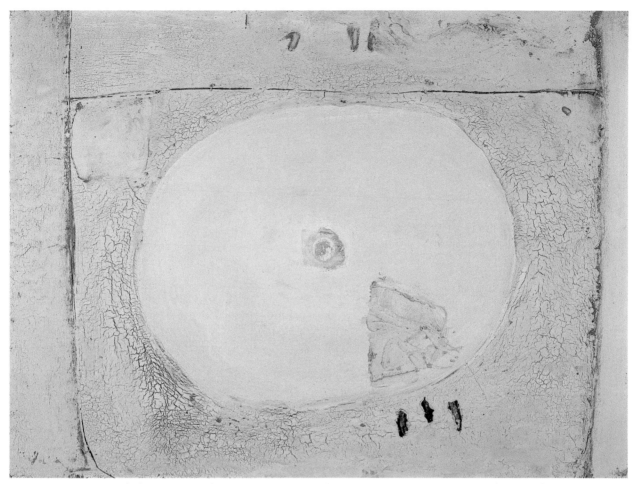

Antonio Tapies (Spanish, b. 1923), *Crackled White*, 1956, mixed media, 30¾ x 39 in. Bequest of Alexander and Henrietta W. Hollaender, 1992.196

My Handkerchief

Wrinkled
tattered
weary fabric.
Where did you find it?

I am astonished at the precise detail
of the surviving corner,
edges torn into bandages
in the war.

Hems severely battered and wrenched
trapezoidal patch heavy with battle grease
cat claw marks
cigarette burns and sand.

Circular mark of its one time ironing
by a pan fresh off the fire.

K-ration stains devoured
by infrequent cold water washes
in rancid pools.

No Cheer.

Richard A. Loescher

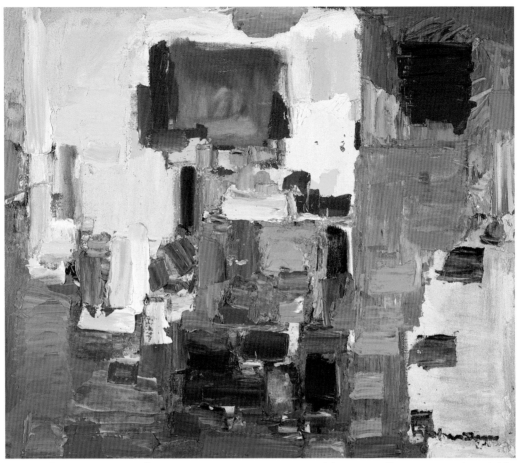

Hans Hofmann (American, b. Germany, 1880–1966), *August Light*, 1957, oil on canvas, 52 x 60⅛ in.
Bequest of Alexander and Henrietta W. Hollaender, 1992.168

Landscape with Heart: Hans Hofmann in Manhattan

Above the slate-gray skyscrapers
clouds are pinwheeling a deep indigo.
Rain flogs the windows; it's Manhattan,
1940, and Hofmann has just awakened
from a dream of an enormous heart.

Alizarin red, he thinks,
picturing a new canvas with the heart
off-center, *a primal red*,
like the insides of a lacquered jewelbox.

He closes his eyes and the heart
reappears, throbbing, its color deepening
to magenta and the ropes
of veins, blue as the throat of a morning glory,
until they are severed,
and the blood spurts raw sienna.

Hofmann has never seen the
inside of a human body
but once as a boy
visiting his grandfather in Bavaria

he stepped from his bicycle
into the doorway of a barn
and watched from the shadows as a farmer
pulled ropes of foamy milk
from the teats of his Guernsey, the milk

streaming into a silver bucket.
In the speckled barnlight, the cow
is a sheen of caramel and white, the farmer,
half-tones of fawn and gray, the sprays
of ivory milk matching exactly
the surrounding fields of hops.

Later that day, the young Hofmann will pedal down
to the canal where sleepy barges
thread their way up the black water.
Now, in this moment, Hofmann is lost
to memory: pale milk and August sun!

Turning to his window
above 8th Avenue, he wonders
how to render this city's heart. Below him,
a yellow sign flashes
in the rain, but his mind keeps skipping

back to the fields outside of Weissenberg
with its seasons of sleet and mud,
the slow cresting of spring
like a woman aroused

for the first time. Here in New York
it's late summer. When the rain stops
the city will be a hopscotch of whites
and grays dabbed with olive-colored
faces, small children dressed in lilac and mauve. *No,*

I will not paint the representational.
I paint what is real: red heart balanced by ocher sun.
Milk and blood. The fierce green engine
flowing in a constant chug.

Dale Kushner

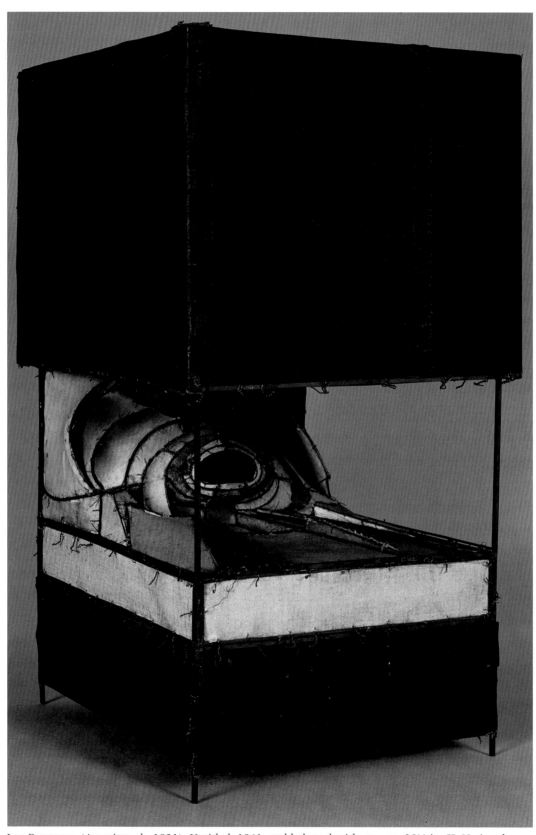

Lee Bontecou (American, b. 1931), Untitled, 1961, welded steel with canvas, 28½ in. H. National
Endowment for the Arts Fund, Edna G. Dyar Fund, and Humanistic Foundation Fund purchase, 1973.5

The Greening

We lived in caves
Licked the water which ran down.
Others had thick houses, drank water de-salted, wore thick sun-goggles,
We laughed when they got skin cancer,
White was better.

We told tales by the hearth of sun-heated rocks,
Fire was not needed.
A great oral tradition grew up,
Sagas about olden days when the sky was blue
Rather than gold.

Solar power ran everything.
Food was very scarce, we ate mushrooms.
The salty sea had killed most fish,
But the rich were keeping a few cows.
We never knew where they got the forage.
Some believed that the cows could eat meat,
But most of the meat was human.
Tales ran rife around the dark hearth.

Fran Rall

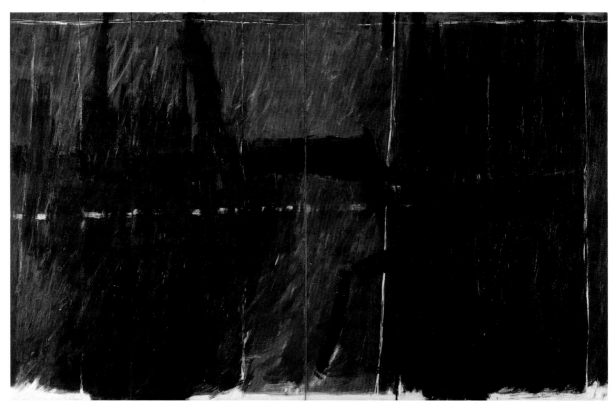

Jack Tworkov (American, 1900–1982), *Barrier Series No. 4* (diptych), 1961, oil on canvas, 94 x 75½ in. (each panel)
Gift of the artist and the Dr. C. V. Kierzkowski Fund purchase, 67.12.1

Face

On the other side
there must be a face—
Flush with exertion perhaps—
Who wears it
has paused to catch a breath
leaning against the dark red barrier
which is rough
like the unshaven cheek of a prisoner

The face is familiar
(if one could see it)
The eyes' shape
The nose
The squareness in the jaw

And of course
the expression
dog-tired
lonely
a little fearful

Steve Timm

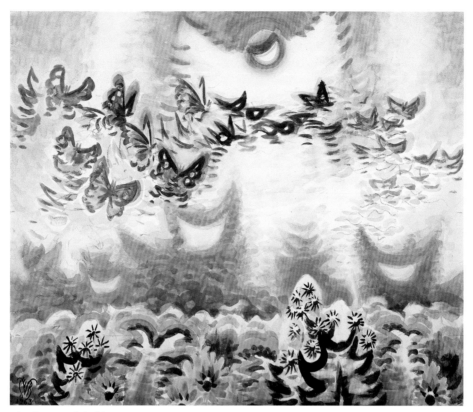

Charles Burchfield (American, 1883–1967), *Migration of Butterflies by Moonlight*, 1963, watercolor on paper, 32 x 39 in. Gift of Mr. and Mrs. Newman T. Halvorson, 1980.57

Migration of Butterflies by Moonlight

Where
 a gothic window can be found
 among the
 flowers while

on high
 the intimation of
 an angel
 and her

moonlit smile
 and arms

are beckoning
 applauding the commotion
 the confusion
 that is
color
 with its lesson and the
 reason for the sky. And where

line
 and hue aspire to be music in this

vast
 and measured
 place this

dazzled

 fluttering space this

hush
 then rush
 of brush uplifting wing

on wing
 on wing to climb

the tilting wind and how
 they are

escaping

 every shadow every
 line and

definition in their

 mad ascending
 dance abandoning
 the

flowers who are
 bidding them

farewell.

 Pell-
 mell they tum-
 ble skyward as they

lead
 and tease
 and draw

 the eye the hand
 that wrought them

 into light.

Eve Larkin

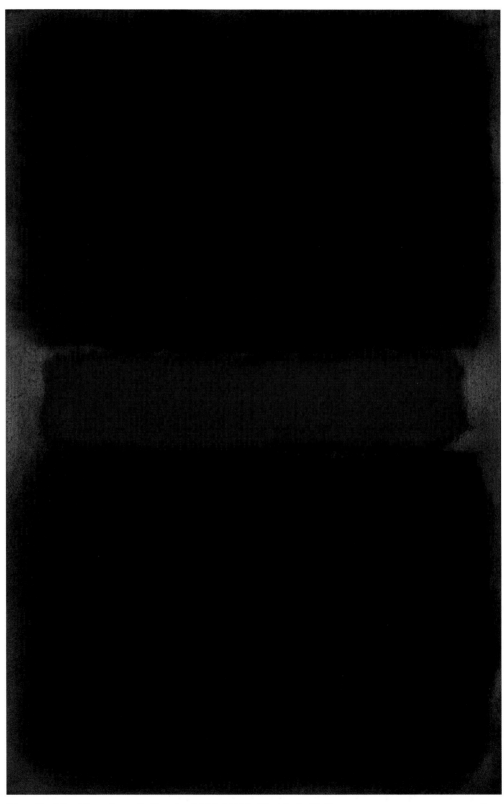

Marc Rothko (American, b. Russia, 1903–1970), Untitled, 1968, tempera on paper mounted on linen, 40¼ x 26⅜ in. Bequest of Alexander and Henrietta W. Hollaender, 1992.190

Rothko

The paintings were of what wasn't there,
as if of the shadow of air.

It smothered you like a pillow, or plastic,
that air you painted, dark and drastic

as all absence, all loss.
And we who live on, because

you painted it cannot avert our eyes.
We see, everywhere, peripheries,

sharpened edges shading into something
as sad as suicide, or painting nothing.

Kelly Cherry

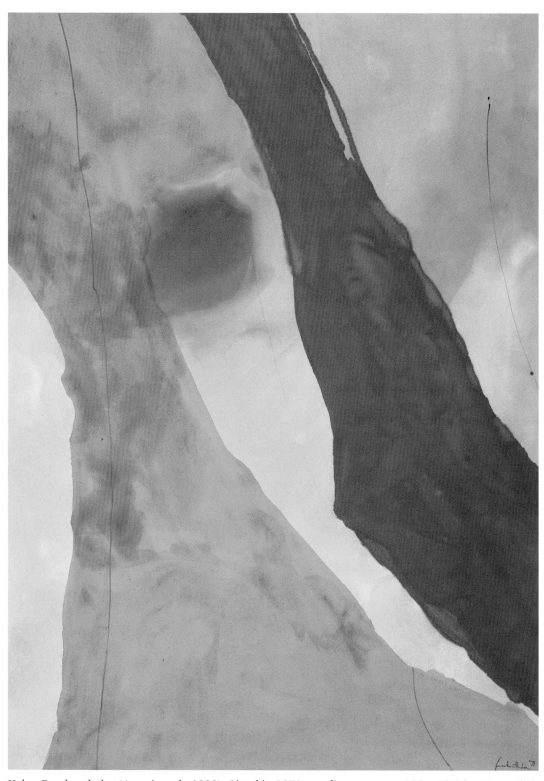

Helen Frankenthaler (American, b. 1928), *Pistachio,* 1971, acrylic on canvas, 109 x 79¾ in. Humanistic Foundation Fund and Thomas E. Brittingham Fund purchase, 71.32

This Painting Can't Be Reproduced

You have to stand in front
of the monumental-sized original

to see its life
stream(ing) female flow
in pistachio
its purple ribboned river
that knows
where we're going
its blood sun orb
moving slowly
towards beginnings/ endings
a flushing out
a flowing through
a coming too
light
breaking
blood
seeping

she has parted her legs
and paint has poured forth
pain has poured forth
from her, from you
opening the pores, parting your lips
breathless breath-filled
feel yourself wanting
to tongue the sheer deliciousness
of original vibrant color
on untouched canvas surface
moving and caught
 still-flowing

Andrea Musher

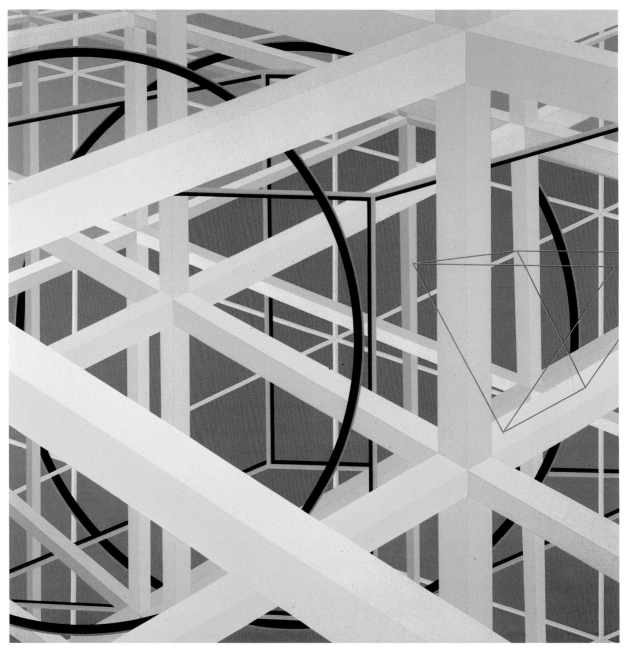

Al Held (American, b. 1928), *Bruges III*, 1981, acrylic on canvas, 60¼ x 60⅛ in. Juli Plant Grainger Endowment Fund and Elvehjem Endowment Fund purchase, 1986.29

Al Held's American *Bruges III*

You've been here:
 when you were swingin' iron
when your Baby threw up on the roller coaster
 that night before the geometry quiz
that year before they shot the old bridge out of the river
 before the hamster died of a heart attack in his exercise wheel
only moments before the clouds left for the last time
just seconds before the mountains flattened themselves like a
 burst boil
and you said,
 "yellow has never done that before."

Jennifer Vaughan Jones

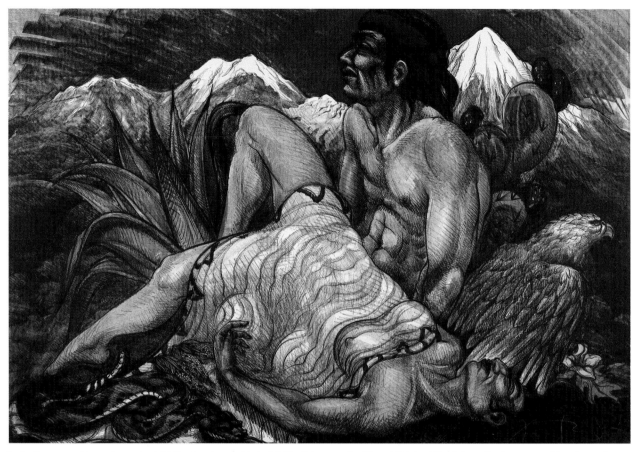

Luis Jimenez (American, b. 1940), *Southwest Pietà*, 1983, lithograph, 30 x 44¾ in. Elvehjem Endowment Fund purchase, 1989.39